CREATE ANYWAY

Become an Empowered Artist
and Create with Confidence

David Limrite
in collaboration with C. Jordan Blaquera

CREATE
ANYWAY

Contents

Before We Begin

I wish you could be a fly on the wall of my studio while I am working. You might be surprised by what you would see. You might see a lot of you in me.

You would see an artist who procrastinates, gets distracted, and becomes frustrated. I try things that work. I try things that don't work. I get stuck. I encounter self-doubts and engage in negative self-talk. I second-guess myself, and sometimes I don't know what to do next. Sound familiar?

On the other hand, you will also see an artist with patience and flexibility and one who has both successes and failures. After 31 years and over 10,000 classroom hours teaching art at colleges, private institutions, and my own workshops—not to mention my seven years as an art school student—I have learned how important mind management is for an artist. Much more valuable, in fact, than technical skills.

Artists' mind management (or mindset) is what happens when an artist develops the ability to direct how they think about all the obstacles and challenges that can come up during the process of creating. These obstacles and challenges could be fear, doubt, procrastination, or an inability to choose what to do next, as well as becoming creatively blocked or feeling frustrated. What makes all

of these so detrimental is how artists let these negative thoughts influence their choices and their ability to create productively and, more importantly, what they make these thoughts mean about themselves, their character, and their potential as artists.

For example, if you allow frustration over "ruining a painting" to get the best of you, you might delay starting your next painting. It might shut down your creativity altogether. Or you might make it mean that you are a terrible artist who creates terrible things. A better approach would be to allow yourself to be frustrated and take a break. You could then redirect your mind toward believing that you are an artist who is just having difficulty with one specific aspect of your painting. You could also tell yourself that, instead of being a terrible artist who can't paint, you just haven't found the right solution yet and that you are in the process of discovering the next step to take with your painting.

This book is dedicated to helping you with your mindset. It is the culmination of my firsthand experience and observations about the artist's journey and how you can overcome the challenges that cause artists to get stuck. My desire is to liberate artists from the self-imposed limitations of fear, procrastination, and lack of confidence, and, in turn, empower them to create with courage, commitment, and momentum.

Although this book is written for visual artists such as painters, sculptors, and photographers, the ideas contained within these

pages apply equally to any creative person, including but not limited to actors, writers, musicians, dancers, and even entrepreneurs. When I use the term "painting" in this book, please feel free to substitute words from your own creative calling. Among the individuals I have worked with, I have coached, mentored, or taught figurative, landscape, and plein air painters, encaustic and mixed media artists, retired schoolteachers and college administrators, psychologists, surgeons, sculptors, lawyers and even a pianist, all of whom were attempting to improve their creative pursuits. The ideas presented here have helped them all. It doesn't matter whether you are an active professional, a self-identified artist, or a creatively-inspired person. This book is for anyone who is on the difficult (but fulfilling) journey of creative expression.

This book is based on the premise that *your creativity matters* and that *you have creative work to do.* My goal is to help you get out of your own way so you can get down to creating. I am not so much interested in what you create as I am in that you create.

This book will help set you on a path to more meaningful and courageous creativity, profound artistic growth, and increased productivity. It will also encourage, motivate, challenge, and empower you to take creative action.

Best,
David

100 Apples

I was stunned. There I was, a student in art school, and my painting instructor had just given the class an assignment to create one hundred paintings of an apple in one week. My immediate reaction? You have got to be kidding. This is ridiculous!

By my calculations, I would have to paint 14.286 paintings a day. I panicked. The sheer volume of work that we were being asked to create in one week was indeed overwhelming. How was I going to create one hundred good, let alone *great*, paintings of an apple in one week?

After class, I immediately got to work. I started out trying to create beautiful, high-quality paintings of apples. After two or three paintings and several hours of work, I realized I was never

going to complete fourteen or more beautiful apple paintings every day for a week. Besides, the first couple of paintings were boring and too academic.

I decided that I was going to have to work much faster and, even more importantly, detach from the outcome. I was just going to have to crank out apple paintings, one after the other, and not care how good or bad they were. After a dozen or so paintings, I realized that if I was going to complete this assignment, the paintings could not be precious to me—which was exactly the reason for the project.

Imagine the crazy apple paintings that sprang forth from my brush after I made this realization. I began painting apples with reckless abandon. I was free. I became more creative. I tried all sorts of styles, compositions, and weird color combinations: a blue and orange apple, an all-black apple, an apple with polka dots or stripes, an elongated apple, an apple created with only two or three brushstrokes, an apple floating in the air like a balloon. Needless to say, I created lots of terrible apple paintings. But the assignment was not to create one hundred beautiful, high-quality paintings of apples. It was to *just paint them*. Get

them done. The goal was quantity, not quality—
which ultimately led to more creativity. The
process became truly liberating and I actually
had fun with it. And I completed the assignment.

This was a project about painting and creativity.
Not preparation. Not thinking. Not worrying.
We were being forced to paint. *Just paint* without
having to worry about quality. This was also a
project about *momentum*. And about creativity
and innovation. This was a project about risk-
taking. This was a project about becoming more
comfortable with making mistakes and about
breaking the grip of perfectionism. This was one
of the best assignments I ever had in art school...
and it worked.

As a result of this assignment, my mindset re-
garding creativity and my approach to painting
abruptly changed for the better. I became much
more open to the possibilities inherent in being
a creator, and I began to really care about the
creative process.

To me, being a creator means being the best,
most empowered artist that you can be. It's all
about making stuff. It's also about managing your
mind, so that you can be free to focus on the

process and not worry about the outcome. The key is to always be creating a lot of paintings (drawings, sculptures, photographs, quilts, poems, etc.), and building momentum, which will help you be more creative in the long run. Expressing your creativity is about creating: the doing, the making, and the time spent. Creating is not about preparing, planning, over-thinking, worrying, or doubting. It all starts with believing that your creativity matters.

2

Your Creativity Matters

Creativity is the desire to bring something into being from nothing. Creativity is the ability to pull things out of oneself and give them shape and form. Creativity is the act of bringing forth something that only existed in your mind— which, after you create it, will then exist in real life. Creativity is the ability to put diverse things together to come up with something new, something you have never seen before.

Creativity is the drive to make your visions concrete and alive. Creativity is as much about the process and your intention as it is about the idea. True creativity requires time, commitment, courage, intention, sacrifice, and risk.

Creating is your passion. It brings you tremendous amounts of joy, happiness and satisfaction.

You love the process. Creating is a priority for you. You can't envision your life without creating. Creating is perhaps one of the most important goals you have for your life. Honor the love, passion, and commitment you have for creating by giving yourself the gift of time spent with your favorite creative activities.

You may ask yourself, "Does the world really need another still life, landscape, portrait, or figure painting? Another photograph? Another sculpture? Another drawing?" You bet it does. If it matters to you, it will matter to us. Show us what you love. Give us your gifts. Your creativity *does indeed* matter.

The key is to begin by believing that your creativity matters.

This book exists to prepare your mind and give you the tools you'll need to be a better, more empowered artist. If you want to unleash your creativity and make art that you love, and if creating is your passion, then one of the most important things you can do for yourself is to begin believing that *your creativity matters.*

It's important for you to realize and accept this. If you don't, it can make any time you spend creating—and any meaningful thing you create—seem "less than" and not valuable or worthwhile. Believe in yourself and in your ability to generate ideas and create them. Your creativity has to matter to you before it matters to others.

One of the best ways to help you realize that your creativity matters is to create your art for yourself, first and foremost. I suggest that you do not create your art for others unless you are creating something specifically for someone else as the result of a paid commission. Believing that your creativity matters will make it easier for you to love the process of creating, and will empower you to give it everything you've got. Ultimately, it's about *making* the kind of stuff *you* want to make.

You are going to feel frustrated, angry, timid, disappointed, stuck, indecisive, reluctant, or just plain uninspired from time to time. The antidote for these feelings is to be committed to your creativity. Show up in your studio on a regular basis and give it your all. No matter the outcome. Loving the process is your first priority. Having the conviction to create the kind of art that

deep down you feel compelled to create is your second priority.

Make the art you want to make. Paint when it's time to paint.

How do you do this? Courage, perseverance, discipline, and resilience. Achieving these qualities begins with believing in your creativity, having a passion for the process, giving yourself the gift of time, and allowing yourself to try, explore, and take risks.

Remember that fear, lack of focus, negative self-talk, reluctance, and being noncommittal can get in the way if you let them. The key is to *choose* not to let them.

Take charge of your creativity. Choose creativity instead of fear.

The key to meaningful creativity involves clarifying your goals, making a plan, committing to the plan fully, and then acting on your plan with

your whole heart, soul, and mind. The more art you make, the better you will get at creating it, and the more confidence you will gain. Which, in turn, will help you begin to realize that your creativity matters, allowing you to embrace your big ideas and aim yourself in the direction of those ideas.

Let's say you have an idea that you are passionate about exploring. But you also have doubts about its merits or worthiness. You may even ask yourself if your idea has a chance of being remotely successful or if it is even worth your effort and time. Is this a great idea, or will it be perceived as frivolous, immature, or derivative?

On the other hand, your idea may possibly be truly interesting and groundbreaking. If it is important to you and therefore worthy of your efforts, say yes to the potential risks along with the time and effort it will take to make your idea a reality. And then set out to create it.

Your idea is important to you. You are committed to making it a reality. You might be experiencing fear and doubt, but you begin. You now have a tremendous opportunity to make something amazing.

Create and take the risk. It will always be worth your effort.

Risk is essential to the process of creativity, and understanding this is important. Without risk, most of what exists today would not exist. Creating encompasses unavoidable risk, and you are never guaranteed anything.

Set yourself up with a positive mindset before beginning to create by coming up with an inspiring statement that empowers and motivates you to get out into your studio and gives you the courage to begin. For me, this is a statement that reminds me that it is time to show up in front of my easel. It is a statement that reminds me that I must create despite distractions, resistance, and fear. It gives me the confidence to go into the unknown, knowing that I can handle whatever the work throws at me. It allows me to confidently accept the realities of creating and of being a creator.

My statement is: *I have creative work to do.* It is a statement that reminds me that I must work no matter how difficult it might be that day. It

reminds me to approach my work with passion and commitment. It reminds me to focus on the process, not the product. Telling myself that I have creative work to do every day sets me up with a very positive tone for the day's work ahead. It gives me purpose and meaning for what I am about to create.

Telling myself that I have creative work to do does not specifically tell me what I am supposed to be creating or how I should be creating it. Rather, it tells me that what I am setting out to do is important.

I have creative work to do makes me stronger and more confident. It reminds me to persist rather than evade the realities of the process, which can be quite challenging at times. Avoiding the realities of creating can lead to quitting or giving up. And this is not an option.

I have creative work to do reminds me that

I should not wait until I am inspired to work,
but should instead become inspired by working.

Other examples of empowering statements are:

My creativity matters to me.
Now is my time to create.
It is my turn to show up and begin.
My priority is my creativity.

Because having a personal statement like this
works so well for me, I urge you to write your
own inspiring statement that will empower you
to get into your studio and create. You can use
mine, take one of my suggestions above, or
write your own.

Next, take responsibility for your own creativity.
Honor your creative time and space. You and
you alone are responsible for doing this. No one
else can do it for you. What allows you to do
this? Passion, intention, courage, and also just
a little bit of *selfishness*. Now I know that being
selfish has a negative connotation. When I use
the word selfishness here, I am trying to help
you stick up for yourself. I am trying to help
you guard your precious art-making time. If
we let them, the daily demands on each of us

can easily pull us away from our creating. But not only is it important to be a bit selfish with our creating time, it is also important for our health and well-being as artists.

In order to have my creativity be more of a priority, I carve out time for creating on my daily to-do list as many days during the week as I can. If I don't do this, it totally messes with my head. It tells me that everything else is more important than my art. Not only is this just not true, it is not good for my self-esteem or the art I create.

Creating fulfills me like nothing else can. It gives my life purpose. It's my passion.

So, to leave my creativity off my to-do list is ridiculous, right? Even if I don't get to my art-making on some days, creating should be a priority as often as possible.

If you aren't already, start putting your creative time on your daily to-do list. Remind yourself that your art-making matters, and that you (as an artist) matter. See if this helps you create more often and helps you be a more productive creator.

Creating is confirmation that you are fully alive. Savor the process and tend to it with delight. Fully engage in the process of creating and allow yourself to bring something into being from nothing. Something that never existed until you made it. Something that only existed in your mind. Something new, beautiful, shocking, thoughtful, odd, or amazing. Something that will now exist in real life. Your passion, energy, and spirit cannot help but show up in the finished work.

By believing that your creativity matters and making your creating a priority, you give yourself more opportunities to learn and make things that you love. Grant your creativity the time and space it deserves to flourish, and then watch your productivity soar to new heights.

CHAPTER 3

Commit to the Creative Spirit

Being a creative person who is tapped into their creative spirit is about doing the work that matters most to you. It's about commitment, focus, and hard work. It is not about waiting for inspiration to show up at your studio door. Being involved in a creative activity, on a regular basis, helps build momentum and leads to better art-making.

Creative acts are born from a combination of personal passion and a willingness to show up and try.

It helps to choose and work on a project that really excites you. One that you are passionate about. One that gets your juices flowing. One

that you are willing to take risks for. One that
you are willing to ignore your doubts and fears
for. Once you have a project that fascinates you,
the next step is to tap into your creative spirit.
The creative spirit is not about being original. It's
about doing the work that matters most to you,
that is personally meaningful to you, and that
is honest, true, real, and authentic for you. The
creative spirit is about self-expression, communi-
cation, expansion, and growth, both as an artist
and as a human being.

I coached an artist who had completed her
degree in art, gotten a job as a graphic designer,
and painted on the side. After a few years, she
got married and had two children. During this
time, her art career got shoved to the side. Fast
forward twenty-four years, when this artist con-
tacted me for some coaching. She was desperate
to get back to her art. Her kids were grown up
and off on their own life adventures, and she
was ready to reignite her creative flame...but she
didn't know how to begin or what to do. She
longed for the days when she could paint in her
studio, but she needed help connecting and com-
mitting to her creative spirit.

We talked through all her fears and doubts. We

set her up with a regular weekly painting schedule. We figured out what she wanted to communicate through her paintings, and what subject matter was most conducive to her ideas. She began painting. But she was rusty at the easel, and her negative self-talk was making it very difficult for her to create. The thing that tripped her up the most was feeling like she had to make up for lost time. She felt that every painting needed to be amazing right now. This, as you can imagine, blocked her creativity.

It was necessary for her to learn how to be an artist all over again. It was important that she learn how to show up, begin, and stay with it, day after day. We worked on managing her perfectionist thoughts. We got her back on track by having her focus on the process of painting. And, most importantly, she decided to give herself the gift of time in her studio at her easel.

It was a long, slow climb back into her creativity. But she is there now and painting like crazy. She is making lots of paintings, some good and many not so good. But she is painting! And happy. All this to say, if you are in this situation of wanting to get back to being an artist and making paintings, I urge you not to wait any

longer. Commit to your creative spirit and your creativity. Paint now.

The process of creating is about learning how to be a better artist. Notice that I said *better* artist, not *perfect* artist. I'll talk more about perfectionism later, but for now, focus on learning more about yourself and your creative process. Learn more about your thoughts and ideas, your subject matter, the technical aspects of your chosen medium, and how you want to use it. Creating involves thinking, exploring, and solitude, among other things. It is about fun, joy, and exhilaration. It's about allowing yourself to be challenged. And above all, it's about the process, the attempt, the time spent creating, and how you approach your art-making.

Learning to be self-disciplined is also essential for creators of any kind. How important is your art-making to you? How important is your creative time to you? What are you willing to sacrifice to make sure that you have this precious, sacred time every day, every week, or every month?

Establishing priorities, setting goals, and carving out studio time is so important for all artists.

No one can make your art for you. No one can make you get out to your studio or force you to stand in front of your easel except you. Be an artist because you want to be. Create what you want to create. Create how you want to create. If you don't go into the studio and work, no work gets done—and the muse will definitely be a no-show as well.

Breakthroughs don't happen while you are sitting there waiting for a breakthrough to happen.

If you wait for ideal conditions, you will be waiting a long time, and you will forever have a blank canvas. My best ideas and breakthroughs have come while I was in the process of creating, not while I was sitting, waiting, and wondering when the next idea would reveal itself. Being involved in the process of creating makes it easier for you to use your creative spirit because you are extremely focused on the task at hand.

The more effort you put into creating, the more creative you will become. Each time you create, you give yourself the gift of opportunity. The

creative spirit is unleashed. Doors open. Possibil-
ities present themselves. Ideas flow more freely.
Mistakes are not mistakes anymore. Solutions
appear to be everywhere. Momentum kicks in
and becomes the driving force.

Choosing to see opportunities allows you to
tap into your creative spirit. Each brushstroke
is a chance to discover something new about
applying paint to canvas. Each new painting is
overflowing with the opportunity to try new
compositions, techniques, and ideas. Opportu-
nity is most definitely a gift that I encourage you
to give yourself by creating as much as you can,
and by approaching your creativity as a chance
to learn anything and everything about your sub-
ject, skill, and medium—all of which will make
it much easier to commit to your creative spirit.
Thinking about *creativity as opportunity* is magic.

The key here is to get into
the studio as often and as
consistently as you can.

Action creates energy. Energy creates momen-
tum. And *momentum is everything* when it comes
to helping you commit to a lifetime of creating.

Remember that *taking action* is at the heart of the whole concept of creating and of being an artist. The activity (the process of painting, drawing, sculpting, etc.) is where you want to be. This is what creates energy. Then, trust that this energy will produce momentum. And momentum will produce results.

I have also discovered that it's important to preserve my creative energy. One way I do this is by knowing what time of day is best for me creatively and energetically. I have figured out that I am a late afternoon/early evening kind of artist. I'm a better writer in the morning and a better researcher in the evening. Knowing this about myself is invaluable. I know exactly what time of day I should be creating, writing, or researching. This allows me to have the right kind of energy for the right activity, and it skyrockets my productivity. When do you have the most creative energy: morning, afternoon, or evening? If you haven't figured this out yet, I urge you to do so. It can be a real game changer.

You might also want to consider what outside influences preserve or deplete your creative energy. Then you can encourage and lean into those things that boost your creativity and

avoid those that drain you. A few things that boost my creative energy are music, silence, being outside, reading, and looking at art. Some things that drain my creative energy are housecleaning, obligations, social media, and politics. Obviously, it can be very challenging to avoid those things that suck the creative energy right out of you. At the very least, do your best to avoid them right before you go into the studio to paint.

Figuring out when to work, what boosts your creative energy, and what drains it is well worth your time. It's all about finding and preserving your creative energy so that you can be the best, most empowered, and most creative artist you can be.

Commit to your creative spirit by asking yourself these 10 important questions that I use with my coaching clients. Get them now at:

www.CreateAnyway.today/creative-spirit

CHAPTER 4

Your Creativity is Calling

Fear, anxiety, doubt, negative self-talk, procrastination, avoidance, mistakes, failures, overpreparing, and lack of inspiration—not to mention all of the other obligations, distractions, and rigors of daily life—are conspiring against you. There are a million and one things that can appear to be obstacles to your creativity. Well, guess what? Nothing actually prevents you from doing your creative work. *You* are the one who is preventing you from working.

You are either creating or you're not. It all comes down to choice. I find it best to choose creating.

No one is going to make sure that you get out into your studio and paint, draw, sculpt, or do what it is that you love to do. Simply put, if you don't do your creative work, it doesn't get done. And I believe it is always in your own best interest to make creating a priority.

I mentor my clients to *create in the middle of life*. The world is not going to shut down three days a week so you can create all day in your studio. Accept the difficulties, distractions and obligations of everyday life, as well as the rigors of the journey, and *create anyway*. Carve out the time. Set up your regular painting schedule and stick to it. Despite it all, *create anyway*.

It is not about how much you accomplish. It's about how *often* you create.

I don't know about you, but if I wait for the perfect time to paint, I never get to it. I never get anything done. And I just end up waiting. Don't wait until the time is right. Don't wait for a time when there will be no distractions or obligations. That piece of time doesn't exist. If you wait for a 4-hour block of uninterrupted creativity time to

magically appear, you will definitely be waiting forever. Please don't wait. Paint right now! You deserve it and so does your creativity.

Create with the knowledge that you might fail. Love the process of creating so much that you *do not care* about failure. Smile in the face of potential missteps and, instead, predict success. Go all in. Find motivation, be it big or small, huge or insignificant. The most important thing is to *answer the call.* Quiet the voices in your head, the negative self-talk, the doubts and fears. Get lost in the *making* of your work. Become totally engrossed in what you're doing and what is happening on the surface of your canvas.

I think it is also valuable to remember that it's not always about the end product. *What* you create is not necessarily the objective. The *action* is what is really important. Engage in the activity. Make a mark. React. Then respond by making another mark. Be involved in the process every step of the way. Get lost in the search to find the right line, color, value, shape, or texture.

Be present during the creation of your work.

Don't overthink it. Too much thinking can turn into a stall tactic. Too much thinking can become an excuse for not painting. Too much thinking can lead to too much research, too much planning, and too much preparing. Don't get caught up waiting until you have your new idea all figured out before you start painting it. Worse yet, don't get stuck trying to paint the painting in your mind. In fact, try *not* to do this. Even if you have your painting fully realized in your head, it usually never ends up looking that way on the canvas. This is because your brain completes the painting in a straight line from start to finish (A to Z). Your brain does not allow for the unexpected, the twists and turns, the lefts instead of the rights. Nor does it allow for the happy accidents.

Love learning as you go.

When you are painting, your eyes, mind, and heart are all creating the painting together, which allows the painting to veer off into the unexpected. When you actually engage in the *activity* of painting, you take your work creatively to places where your brain is incapable of going. Art is a visual process. You start with a color or a shape or a line so your eyes have something

to look at and respond to. You might make a red brushstroke. Your eyes see this red mark, and your heart and soul respond to the visual stimulus as well. Together with your heart and soul, you assess this brushstroke. Next, your hand and brush react by making the next mark. And so it goes.

Color, mood, emotion, and drama engage your whole being. Every brushstroke you make, every line you draw, every color you add changes a painting, both significantly and in ways you could never have predicted or imagined. You are painting and answering the call of your creativity.

For 11 tips to improve your art and the art-making process once you are in the studio, go to:

www.CreateAnyway.today/improve

CHAPTER 5

Show Up, Begin, Stay With It

Now that you have committed to your creative spirit and embraced risk-taking, it's time to show up. It is important to foster your creative spirit by painting as often as you can—if for no other reason than to build momentum.

Showing up requires that you *start before you are ready.*

Here's some breaking news: You will never be fully ready. You will never be as prepared as you want to be. Remember: *start before you are ready and learn as you go.* You don't need to learn more drawing skills before you tackle that landscape painting.

I used to feel as though I had to be completely prepared before I could begin to create. As a

result, I didn't get anything done. I found that I spent more time *preparing* to work than actually working. Imagine focusing all of the energy that you spend trying to decide what to paint (or preparing to paint, or worrying about it, or avoiding it) on *actually painting*.

When I first became a student at the big, high-powered art and design school that I attended, I was very intimidated. The facility was exceptional, the teachers were top-notch, and all of the other students seemed to be so much more talented than I was. I often hid in the library looking at art books instead of doing what I should have been doing, which was practicing my painting.

When I did make an appearance at my easel, my paintings didn't look like I had painted them. One of my instructors said that I was looking at too many art books, and I was just copying the styles of my favorite artists. *Gulp.* His solution was to ban me from the library for an entire semester so that I could paint and develop my own style. Which I did. And as a result, my confidence level skyrocketed, my paintings got better, and I started developing my own style.

The more you show up and work (rather than spending time preparing to work or, worse yet, waiting until you are "ready"), the more courage you will generate. Which will allow you to take bigger and bigger risks. Which will then infuse you with greater amounts of confidence to push your art further.

It is imperative that you commit to a regular painting schedule and stick to it.

That said, it is one thing to show up for your regularly scheduled creativity session, and yet another thing to actually start painting. Still yet, it is another thing to *continue* working (especially when the going gets tough).

I recently mentored an artist, and we were having a difficult time setting her up with a regular painting schedule. Getting her to commit and actually go into the studio was proving to be quite a chore. After many mindset discussions, we finally got her into her studio for two hours of uninterrupted painting. The next day when I asked her to show me the painting that she had worked on, she revealed that she had nothing to

show me. She told me that when she went into the studio, it was too messy for her to paint in, so she decided to spend her two hours cleaning and tidying up instead of painting. She had showed up in her studio, but she did not actually begin working.

Showing up and beginning are indeed two different things. Creativity is much more productive when you do both.

Show up and work until you can say that you have made an honest go of it. Say *yes* to your creativity, not *maybe*. *Maybe* is a momentum killer. *Maybe* is as good as a *no*. I would prefer that you say, "No, I am not going to paint today," rather than, "Maybe I'll get around to painting today." If it's *maybe*, you won't. And it will gnaw at you all day. At least if you say no, then you can go about your day without guilt.

As a younger artist, I often made excuses for not spending quality time creating. Not having enough time was a very dangerous excuse for

me because it turned into a bad habit and seriously damaged my productivity.

Do any of these sound familiar? *I'm too busy with other things. I don't have time to paint. I have so many other obligations. There isn't any time left in the day to make art. My family needs me. I'm waiting until I have several hours (or days) in a row so I can really focus on my paintings.*

I hate to break it to you, but there's never going to be enough time or the right time to devote to your art. If you're waiting for the perfect amount of time to create, you will be waiting forever. And you won't be creating.

Time is not your friend. Time is not a champion for your creativity. Time is never going to make it easy for you to be an artist. Life is not going to stop and allow you to spend time painting.

Giving yourself the gift of time spent creating will always be worth it.

Eliminate time as an excuse. Most of us have more available time in our day than we think we

do, as we tend to have several periods of wasted time in our schedules. If you analyze each day of your week, I am sure you will discover the time you need to add creativity into your life somewhere. In addition, be realistic with your schedule. Don't overbook yourself. Don't set unreasonable demands on yourself or your time. If you set yourself up with a schedule that you cannot stick to, you will be at a disadvantage from the start.

Now that you have your schedule, post it where you can see it. Tell your family and friends what your schedule is and ask them to honor it by not disturbing or tempting you with other activities. Do not be easily distracted by the phone, email, social media, family, friends, pets, etc. They will all be there when you are ready for them. Make it even easier to avoid distractions by muting your phone, turning off your social media notifications, and/or shutting down your computer.

There is always going to be something to do that we think is more important than making art. I know that family, health, and making a living (just to name a few) can take precedence over creative time. But what I am really talking about here is the little stuff that we decide to do instead of choosing to make art, which we then

justify with a reasonable-sounding excuse in the moment. But this is actually very detrimental to our long-term creativity.

I know I have certainly been guilty of procrastination. It can be ridiculous. Many times I have chosen to wash the car, mow the lawn, do the dishes, or clean the house instead of choosing to go into my studio. Why do I do this? I might be procrastinating because I am having trouble completing a painting, or because I want to start a new painting but am not sure where or how to begin. Or it could be because I know that there are things I want to add to a painting, but I am afraid that if I go back into it, I will ruin it. Usually, none of the tasks that I chose to do rather than paint were things that needed doing at that moment. The dirty dishes would have still been there waiting for me after I had finished painting.

To be honest, I have never once regretted choosing to take the time to create. But I have, more often than not, regretted choosing to clean the house instead of painting.

The more excuses we make for not showing up in the studio, the easier and easier it is for ex-

cuses to become a habit. Excuses are our enemy. The house, dishes, and car may be clean, but that painting in progress on your easel has not been worked on for weeks. If making art is a real passion of yours, choose studio time. And beware of the excuse trap.

Sometimes it can be difficult getting ourselves out to the studio because our lives are filled with commitments and responsibilities. In addition, unexpected things always come up. The problem is that we are easily distracted, and we allow unexpected stuff to derail us. Instead of fitting your creativity time around the rest of your daily life, try fitting your daily life around your creativity time. The important things like family, health, friends, and your day job (if you have one) will still be attended to and taken care of.

Set yourself up with a reasonable daily or weekly painting schedule, or give yourself the goal of putting in 12-15 hours a week in the studio. Then, stick to your schedule and don't allow distractions to get in the way. If you are serious about your creativity and if you are passionate about making art, you can and will make this work for you.

Be passionate about prioritizing your creativity.

You may notice fear, but *create anyway*. Have fun. Love the process. Work with materials and on surfaces that you love. Work with a subject matter you find fascinating. I have been a figurative artist all my creative life. I am passionate about drawing and painting the figure. I love the mood, emotion, and drama that comes with interpreting the figure. If you discover what you are passionate about, you will be compelled to get into the studio often and you will create better work.

I am encouraging you to take your art seriously and make regular time for your creativity. Don't wait for the perfect circumstances, the perfect amount of time, or the perfect thing to inspire you. Show up and begin to work.

6

The Courage to Create

It takes courage to make *all* the choices and decisions inherent in being creative, such as the courage to:

Decide to paint today.

Walk through the door of your studio.

Decide which new project to pursue, which painting in progress to work on, or which painting to abandon.

Begin.

Pick a surface to work on, which brush to use, and which color to start with.

Make that first brushstroke.

Avoid distractions.

Be alone with your own thoughts.

Give yourself permission to try.

Take risks.

Make mistakes.

Fail.

Succeed.

Like what you have just painted.

Hate what you have just painted,
and have it be okay.

Allow your work to become something
you didn't imagine or to take you places
you didn't expect to go.

...And the courage to get up the next
day and do it all again.

I wasn't kidding. Being an artist takes a lot of
courage. Now, while you might not be successful
at summoning the courage to take on all of these
all of the time, you can battle and persist and
push through. Because that's what artists do.

That said, I don't think courage comes naturally
to many artists. I was not born with courage,
especially when it came to taking risks with my
art. (Remember, I used to hide in the college

library.) I had to *learn* to be courageous. I had
to *practice* being brave. I have had to *overcome*
countless fears every time I enter the studio. Still
do. I try to approach every new painting with
the intention of being bold and fearless; how-
ever, sometimes intentions are not enough. It
takes courage. Which for some artists, like me,
requires learning and practicing.

Creating a painting is a
powerful and profound act
of courage. Art-making has
everything to do with
courage, confidence, and an
ability to show up, begin, and
stay with it. Day after day.
Painting after painting.

Often my brain gets in the way of my creativity.
That is, my heart and my intuition want to go
one way, but my brain wants to go another. My
brain thinks it knows how to make art and how
to create. But it doesn't. My brain knows the
rules and wants me to be conservative and care-

ful. My brain does not want me to be too risky. It wants me to play it safe and just stick with what I know. But my heart and soul, which are really where my creativity comes from, want me to go for it, take risks, try stuff, be curious, play, explore, and attempt what I have never done before.

The brain is very powerful. Because it thinks it knows, it often gets in the way. In my attempts to be creative, if I could turn off my brain, let my heart and soul be my guides, and just go for it, my creations would be so much more exciting. And I would have so much more fun creating them. I get to this point every once in a while, but not often enough for my liking. Yet I keep at it because I love what I do. And when I *can* achieve this, it feels amazing.

Years ago, I was the Director of Education at a small art school in Los Angeles. We had classes for kids, teens, and adults, and we had exhibits for each age range. The kids' exhibits were always the most exciting. So much so that the adults were amazed (and a bit jealous, I think) at how free and loose the kids' paintings were. I think the reason for this is that kids have nothing to prove. Put some paint, markers, and crayons in

front of children, and all they want to do is play and express themselves.

Adults tend to want to get it right, be correct, and prove (to themselves and others) that they can do it and do it well. I get it. But this is just our brains getting in the way. When you are crossing the street, look before you leap is the right way to go. However, when you are making art, it may be better to *leap before you look*.

One of the hardest things for me to do is push myself and my art into areas that are still unexplored. It is so much easier to stay where I am, especially when my creativity is going well. And when it's *not* going well, it feels much safer to revert back to techniques that are comfortable and familiar. My brain makes it easy for me to do this. However, this kind of thinking does not propel my art forward or lead to innovation. *Being comfortable* and *feeling safe* are never satisfying in the long run, and the work created with this mindset always ends up looking timid and uninspired.

My work looks much more interesting when I set a few goals for my painting and then make a conscious effort to push those boundaries just

a bit. With each successive painting, I try to go further than I did with the last painting. This approach is a bit risky, but it usually leads to more interesting, creative, and exciting work.

When I clear my mind of expectations, focus on process, maintain a sense of spontaneity, eliminate the fear of failure, and trust my heart and soul, I am much more inclined to push into areas that I have not yet explored. Unfortunately, sometimes I cannot get myself into this bold frame of mind. When that happens, I limit exploration, which then keeps me mired in old, familiar, and uninspired habits. Maintaining a sense of playfulness, a hunger to learn, and a mental attitude that allows me to feel as if I'm capable of attempting anything is what keeps art-making fun, fresh, and inspiring.

Uncertain outcomes can lead to fear, because fear hates uncertainty. Create anyway. Remember: Action quiets fear.

You are a creative person with ideas. You want to express yourself and bring your visions to life. This means that you will be traveling into the

unknown. A lot. You will be curious. Your days in the studio will be filled with experimenting, exploring, trying things, and taking risks. As a result, you will be bombarded with uncertain outcomes: What is going to happen when I try this? How will it look? Is it going to work? Am I going to like what I have created? Can I pull off this technique? Can I do my subject matter or idea justice?

Dance with uncertain outcomes and expect the unexpected, especially when you're trying something new, experimenting, exploring, and pushing limits—which is pretty much every time you engage in your creativity. When the unexpected happens, embrace it as best as you can. The unexpected could be the best thing to happen to your current work. Enjoy it. Don't freak out. Breathe. Relax. Give what just happened a moment to sink in. Part of the fun of creating is when the unexpected happens. For me, the result is very often much better than I could have imagined.

When the unexpected happens, learn from it. Don't try to keep unexpected things from happening by playing it safe. If you need help with experimentation, exploration, and risk-taking, try asking yourself, "What if?" and "Why not?"

"What if?" comes first. What if you repaint the background bright red? What if you paint that banana purple instead of yellow? What if you give the figure in your drawing three arms instead of two? And then you choose *courage* by asking yourself, "Why not?" You say *yes*, and then you make your first *attempt* at creating your new idea.

Take the chance. You run the risk of failing, but you also invite success. Open the door to learning. And allow a breakthrough to enter.

There are no guarantees. You decide to try *anyway*. And once you do, give it your all. Give it your best shot. Don't worry about what will happen. At the moment, don't concern yourself with the outcome. You've got an idea that you think is worth trying. Enjoy the process of trying it. Accept that some of the things you try won't work. However, the exciting thing is that some of the things you try *will* work.

Start from a place where not knowing is okay. The more you create, the more courageous you

become and the more chances you are willing to take. The only way to fail is to quit. Regular, continuous creating builds momentum, allowing you to take more and more risks. Taking risks builds courage. Having the courage to risk builds confidence. Paintings created with courage almost always turn out higher in quality and are way more interesting than paintings created under the influence of timidity, preciousness, and fear.

Every new creation is an act of courage, faith, and trust.

Creating is a bold thing to do. Have the courage to start, and then trust what you already know how to do. Believe in yourself and have faith in your skills and abilities. Replacing your doubt and fear with action will then lead to confidence. Create in spite of possible rejection, judgment, and criticism. The art you create is far more important than any criticism of it. It takes courage to make something, put it out in the world, and show it to people.

Be a better artist by embracing the willingness to work hard, make choices, experiment, risk failure, and take leaps of faith. Trust your choices. The

moment I doubt my ability to make the right decisions, my painting is bound to fail.

For an artist-in-residency project, I began the first of ten large-scale, mixed media figure paintings by sketching a rough block-in. As soon as I finished this first sketch, I knew immediately that I now had another decision to make. While I really loved the way that I had drawn this figure, it was way too big. I had wanted to get more of the legs into the composition.

My choices were to either leave it alone (because I loved the way I had initially drawn it), or redraw it in order to fit the legs into the composition. Should I play it safe and settle for what I had drawn the first time, even though I wanted a different composition? Or should I trust my instincts and my skills and attempt to redraw the entire figure again in order to achieve the composition I truly wanted, taking the risk that I may not be able to draw it as well this time around.

I'm glad to report that I trusted my instincts, my skills, and my decision-making, gathered my courage, wiped out the first drawing, and proceeded to draw it again. As soon as I made

the decision to redraw it, I felt empowered. This
second attempt came together beautifully. And,
I got the composition I wanted in the first place.

Having faith in my ability to make a difficult
choice allowed me to trust myself and my skills.
This made a huge difference in allowing myself
to push forward and create what I really wanted
to create. Which, incidentally, took a lot of
courage as well. By the way, it often takes me
many attempts to get a result that I can live with.
This can be tremendously frustrating; however,
more often than not, my desire to realize my
vision, coupled with my interest in wanting to
learn and get better, allows me to keep at it until
I get the result that I want.

Have a strong intention
to always be pushing your
art forward to the next
higher level.

Don't settle for what is safe. Remember, there
is always something to be learned from failure.
Every time you make a mark or a brushstroke,
you risk failure—but that's what artists do. We

possess the courage to create our work and to risk it all with every brushstroke. This is what makes artists, artists.

Every brushstroke is a choice that you get to make. I say "get" to make because, to me, making art is a privilege and an honor. Have the courage to choose. Some of your choices will not produce the result you wanted, but even then, at least you are moving forward. Choices are a part of creating. Trust in your ability to choose, to evaluate, and to make different choices if your first attempts don't work out. If you don't have the courage to make decisions, it will be much more difficult to create—let alone finish—any paintings at all.

It does indeed take courage to be an artist, but you have that courage. You create in spite of whatever comes your way.

To get 21 tips and practices that will show you what it takes to create and how to become a better artist, go to:

www.CreateAnyway.today/what-it-takes

7

Momentum is Everything

As I discussed earlier, activity creates energy. Energy creates momentum. And momentum produces results. Momentum is *everything*, and it's more powerful than you might think. Momentum is a game changer. Momentum helps you create in the middle of everyday life. It is a powerful force against distractions, obligations, and the obstacles of daily living. Momentum starts with creating good habits and continues with an artist's commitment, dedication, and focus.

Dive in and start. Choose to gain and maintain momentum.

Trust your intuition and your talent, and begin to head in the direction of what you want your

paintings to look like. Then, keep at it. *Quality* doesn't matter at first when you are trying to establish momentum. The important thing is to just make stuff. Lots of stuff. Work on a *regular basis.* I make my best work when I paint every day. Of course, painting every day may not be possible for everyone, so do the best you can.

I suggest a minimum of four days a week in order to gain and maintain momentum. This does not mean that you have to paint all day (although wouldn't that be nice!). In order to build momentum, 12 hours a week would be a good start. That's three hours a day if you are painting four days a week. Of course, these are just suggestions and, obviously, more would be better. What I can say decisively is that the more I paint, the better I get, the more momentum I build, and the more I *want* to paint. The more I paint, the better everything else in my life is too, including teaching, coaching, and writing.

Momentum will not allow you to stop creating. In order to have momentum work for you, it is very important that you get yourself to a place where you are just creating, just making art. Not reflecting. Not thinking. Not judging. Not criticizing. Create as much and as hard as you can for as long as you can.

Not analyzing or critiquing my work, while I am in the process of creating it, helps me create more freely and unencumbered. I know this might sound like a no-brainer, but many of my students analyze each brushstroke *as they are applying it to the canvas.* Doesn't sound very fun, does it? And it isn't. I know, because I used to be one of those critique-each-brushstroke artists. I used to worry my paintings into existence by being overly concerned about every brushstroke being perfect.

This approach completely killed any and all spontaneity. It made me question my ability, skill, and talent. It opened the door for self-doubt to creep in. And, surprise! Lots of self-doubt barged right through the door that I had cracked opened. It turned me into a nervous and apprehensive artist, which was not fun.

While you are creating, *just create.* While you are painting, *just paint.*

There will be plenty of time tomorrow to analyze and critique what you have done. Or the day af-

ter that. Take your brain out of it and just create.
Don't worry about whether what you are doing
is right or wrong, good or bad, beautiful or ugly.
Breathe. Play. Relax. Have fun. Go for it. Learn
from me and don't analyze each brushstroke
as it is being made. A more in-depth critique
of your work can come after you have taken a
prolonged break from working on your painting.
Fresh eyes and a fresh perspective can lead to a
more productive critique. Remember: critiquing
your work is a very different thing from creating
it. Making art is very different from judging it.
Keep the two separate from each other.

If you are a painter, paint
hard. The more you paint, the
more you *will* paint.

The more art you make, the less precious your
paintings will become and the more risks you
will take. This also means you will make more
mistakes. However, the more mistakes you make,
the more you will learn, and the more creative
you will become. (Remember my story about
painting 100 apples?)

One of the ways I motivate myself and maintain momentum is to always leave my studio at the end of the day having made a short list of things that I know I want to do to my painting the next time I work on it. I often leave some things unfinished on purpose, but at a stage where I already know what to do next. I can then begin the next painting session knowing right where to start. This way I can jump right into my work without a loss of momentum.

Promise me that while you are creating you will do your best to create with no self-censorship, no inner critic, and no judgment. Doing this won't guarantee that your work will not have its flaws and imperfections, but it will help you to be more fearless and allow you the freedom to make mistakes without beating yourself up. Focus on the process. Always. Not the end result. You can always come back and tweak the painting later. Paint hard and build momentum. The process will acquire a life of its own. Creating and working hard, more often than not, energizes rather than depletes.

Now, let's talk a bit more about procrastination. Just so we are all on the same page here, procrastination means *to put off doing something*

until a future time, to postpone or delay needlessly.
Procrastinating doesn't feel good, and it's also a
momentum killer.

If we have a great idea for a painting or a series
of paintings, if we are looking forward to explor-
ing a particular subject matter, or if we can't wait
to try out a new technique or style, why in the
world would we procrastinate? One word: *fear.*
So often, fear leads to procrastination and pos-
sibly to never even starting anything at all.

Create anyway, knowing
that once you begin to create,
most (if not all) of your fears
will dissipate.

Once I am in the process of painting, doing so
on a regular schedule, and building and sustain-
ing momentum, my fears recede. It becomes all
about painting, creating, being involved in the
process, and having fun. There is no time and
energy to be fearful.

I have found that procrastination often happens
when an artist has not found the thing that

fascinates them enough to allow them to get lost in the process. In my experience, fascination is essential to creativity. I am fascinated with process, the act of creating, and the journey. I love to make stuff. I love to create something out of nothing. I love working from the figure and exploring the mood, emotion, mystery, and drama that are involved while working with this subject matter. I love creating something that never existed before. Creating is one of my favorite things in life to engage in, and I let nothing keep me from it.

Don't get me wrong: I get distracted, complacent, fearful, and frustrated from time to time. But I keep at it, if for no other reason than to keep my momentum going. The key is fascination. When I get derailed, my fascination with process is so strong that I am able to get back on track quickly. I have found a subject, style, and technique that I am fascinated with. This has been essential to my productivity and creativity.

In addition to procrastination, we must talk about perfectionism. Like procrastination, perfectionism is also a momentum killer. Although being a perfectionist sounds like a noble thing to be, it creates havoc for artists and their creativity.

Perfectionism actually weighs you down, stunts your growth, and leads to procrastination. It often takes the form of waiting: waiting for the perfect amount of time, the perfect moment of inspiration, or the perfect set of circumstances in order to be able to create. It can also take the form of thinking you have to create the perfect drawing before you begin to paint or believing you have to have the perfect lighting, the perfect music, or the perfect plan for creating your painting before you begin.

Many artists that I have mentored talk about never having the perfect block of time to devote exclusively to creating, so they never create. This is a form of perfectionism. If you have 15 minutes, create! Don't wait. Waiting is not helpful at all. Make a couple of marks. Glue down a piece of collage. Paint a color in the background. Start. Do something. Anything. Build momentum. Keep at it. And do your best to have fun with the process.

I once mentored a client who, even after we worked so hard to get her on a regular, weekly painting schedule, was still having trouble fitting her creativity into her daily life. She had a job and a long commute. She liked to spend time

with her husband, relaxing in the evening. What was really holding her back was that she felt as if she needed at least two-hour blocks of time to even begin painting. As a result of this thinking, and the fact that two-hour blocks of time were few and far between, she was not getting any painting done.

We took a serious look at her daily schedule, hour by hour, and we discovered a few things. When both she and her husband got home from work, her husband would go work out every night for about an hour before they settled down to relax and hang out with each other. Well, what do you know? She realized this was an opportunity to have at least one hour each evening to paint in her studio. How about that? It was just a start, but that was all she needed to get going. She also began to look more closely at the rest of her day and discovered that she had about a half hour each morning, which she began using to work in a sketchbook.

I think the lesson here is that you must try to do everything in your power to build and maintain momentum. This includes: creating as often as you can, having a subject matter you are fascinated with (as well as materials, surfaces and

techniques you love working with), focusing on process not outcome, and finding as many pockets of time in your daily/weekly schedule that you can exclusively devote to art-making.

And then, allow nothing and no one to stand in your way.

.

CHAPTER 8

Guess
and
Correct

A technique that I use to help battle perfection-
ism and procrastination is *guess and correct*. This
technique promotes *not waiting*. Not waiting for
the perfect time, conditions, inspiration, pencils,
brushes, or color mixture.

Start to guess and correct by making your best
first effort. Then, make the necessary adjustments
and try again. Your first attempt does not have
to be perfect—nor does any attempt, for that
matter. I tell my students that in order to birth
a new drawing, you make your first attempt and
then spend the rest of your time correcting that
first attempt. This is a much less stressful way of
creating because it takes the pressure off having
to get it right the first time—or the second,
third, or fourth time! At this point you are just
guessing and trying to find a way in.

I also tell my students to always predict success but accept the possibility of missteps, miscalculations, or even failure. If failure happens, look at it as a learning experience and an opportunity to move closer to what you really want your art to look like. As a result, you learn what didn't work or what you don't like, which nudges you closer to your desired results.

Are you waiting until you are able to mix that perfect color before you actually start painting? Are you tidying your studio instead of starting your next piece? Are you waiting to make those first perfect pencil marks as you stare at your subject, hoping to see it more clearly? Were you all fired-up to start painting until you got into your studio and stood in front of your blank canvas or painting in progress, unsure of how to begin or what to do next? If any of these resonate with you, you have stalled out. You have lost momentum. You have allowed fear to creep in. Your confidence may have taken a hit. You have slipped into waiting mode, and you are not taking advantage of guess and correct.

The only way to get yourself out of this is to roll up your shirt sleeves and get to work. Dive in. Don't wait. It is now time to find a way back

into your painting by guessing and correcting.
Give it your best guess. Mix the best color that
you can at that moment and then start painting
with it. After a couple of strokes, you will either
like it or you won't. Now you have something
concrete to respond to. If it's not the right color,
try mixing it again. After your first attempt (your
first *guess*), if it is not what you want, you get to
correct it by making the necessary adjustments—
and then you guess again.

Every time you guess and
correct, you learn that much
more about your subject, your
ideas, and your technique.

If you try to get it right the first time, you are
doing yourself a disservice and placing yourself
at a disadvantage by putting too much pressure
on being perfect right away. (News flash! You
will never be perfect.) Also, when you begin a
drawing, it takes a while for your eyes to start
seeing all of the intricacies of your subject mat-
ter. As you draw, your eyes see more and more
of the details that they may have missed at the
beginning of the drawing session. If you try

to create a drawing that is perfectly correct on your first attempt, you are not giving your eyes a chance to really see all there is to see. And as a result, your drawing may be at a disadvantage in terms of accuracy.

The important thing here is to begin. Get going. Treat your art-making as if you are on a journey, a search to find the best line, tone, value, smudge, shape, edge, texture, and color that you can at this time in your development. And then go from there.

Guessing and correcting (searching and learning) can be messy. It may take some time. You will most certainly create some horrible colors or less-than-inspired lines. But every time you guess and correct, you will learn so much about your creative process. With each effort, you will get closer and closer to what you really want to achieve.

Remember my technique of asking, "What if?" This can be used equally as well here. What if I try this color? What if I experiment with this technique? What if I change this softer line to a much more aggressive line? "What if?" is a wonderful game for an artist to play; it puts the

emphasis on creating and making something rather than on judging, evaluating, critiquing, or procrastinating.

You don't have to have it all figured out before you begin. You don't have to have all your questions answered right away. The thing you are creating will answer many of your questions as you work on it. Questions will come up throughout the entire process that will require you to make choices and decisions. And you will make them.

In order to create anything, listen to your heart. Hear what it has to say. And trust it.

I believe this involves doing what feeds your artistic soul. Doing what makes you happy and brings you joy. Doing what fills you up with gratitude. Doing what challenges you and allows you to learn. Doing what you are passionate about. Diving into your creativity with these things in mind will allow you to have faith in your ability to create what you want to be able to create.

Creating good, interesting, or thought-provoking art is difficult and challenging. However, this does not mean that art-making cannot be fun and joyous. For me, the key is to focus on the *making*, the *doing*, and the *guessing and correcting*. My finished pieces are so much better when I get myself to focus on the process and not on the end product. Art is best when it comes from the heart, not the brain. Make a commitment to enjoy every step of the way if you can, even if it is not going well. *Especially* if it is not going well. Accept the natural ups and downs and highs and lows of the entire process.

Remember, creating can be a messy process filled with fits and starts, successful as well as unsuccessful attempts, risk-taking, and lots of experimentation. Aim to do the best that you can in any given moment. *Guess and correct* will help you create from a place of engagement. This will allow you to gain momentum and give you a shot at creating something truly profound and beautiful—and maybe something that you are satisfied with or even love.

The creation of a painting has three distinctly different phases: Before, During, and After. Learn how to focus your mind during each phase by going to:

www.CreateAnyway.today/before-during-after

9

Action Quiets Fear

In attempting any creative endeavor there is going to be fear—and there is nothing we can do about this. Fear is going to exist.

Let's agree to be afraid and create anyway.

Start. Begin. Try. Make the first attempt. Answer the call to create in spite of fear. Start from where you are right now. It is not useful to worry about past successes or failures. Worrying about what will happen or how good or bad the result might be doesn't serve you either. If fear has you in its grasp, it is important to start working even if you don't know what you are doing.

Fear of what?, you might be asking. Fear of choosing. Fear of starting. Fear of not being able

to do what you want to do. Fear of rejection. Fear of failure. Fear of not measuring up to someone else's standards, such as a teacher, spouse, friend, or another artist you know or admire. Fear of not measuring up to your own standards. Fear of succeeding and then not being able to repeat your success. Fear of suddenly not knowing what to do right in the middle of a painting, and then getting stuck and shutting down or even quitting. Fear of showing your work to other people. Fear of you or your work being judged. Fear that you will finally have to admit that you are a serious artist and not just a hobbyist, thereby increasing expectations. And on and on and on.

What is the antidote for fear? *Action.* Action quiets fear.

You're going to have fears. I have fears. We all do. So, what *can* you do? Acknowledge your fears, whatever they are. Know that they are going to exist. Accept that there are going to be fears, and *create anyway*. Actively creating will dissipate your fear. When you take action in spite of fear or anxiety, you will be amazed at what can happen. You will be a much better artist by *actually creating* rather than spending time *worrying*.

One way to combat fear is by attempting the thing that you are afraid of. Begin, and approach your work confidently, as if you know exactly what you are doing. That is, act as if you have it all figured out, even if you know you don't. Sometimes when I am starting something new, it helps me to get going if I tell myself, "I've got this." Acting as if I know exactly what I'm doing gets me to jump in and start.

Most of the time, when we are struggling with fear, self-doubt, lack of focus, indecision, reluctance, or being noncommittal, we do the opposite. We don't take action. We shut down. We do not attempt our creative work. We shy away from working at all costs. Instead, I urge you to face those fears, whatever they may be, get out into your studio (or wherever it is that you do your work), and *create anyway*. Remember: it's all just paint, brushes, and canvas.

Find a way into your creativity by taking action. This requires making one brushstroke at a time, evaluating, and then responding with another brushstroke. You make a choice, try something, make a mistake, correct it, make another mistake, and try something else. It helps to be patient and flexible. Let the painting unfold over time with

ease. Collaborate with your painting. Be involved in the process. This is what creating looks like.

The important thing is to start and build momentum.

You build momentum by showing up and working regularly. Doing something is better than doing nothing. You might find a way in by allowing yourself to show up and begin painting (even if you are afraid) for at least 30 minutes. You may find that you become so engaged, so excited and thankful for the opportunity, that all of a sudden four hours have gone by and your fear has dissipated. The more you get into the studio and the more you allow yourself to show up, the more confidence you will gain—which will, in turn, reinforce the idea that your creativity matters—and the less afraid you will be.

When I use the phrase *find a way in*, what I am really talking about is doing whatever you need to do in order to get out into the studio, pick up a brush, dip it into paint, make a mark, and begin creating. What brush, color, texture, or technique will light a fire within you to begin *in spite of* the fear you may be feeling? The

most important thing here is to begin. Find a way to get going. I often start by collaging some paper shapes onto my surface. When I do this, it automatically suggests to me where the figure should be placed. Then I start drawing and, before I know it, I am *in*. But it could be anything: scribbles, a wash of color, a random mark or smudge applied to the surface.

A while back, a student in one of my college classes was having an extremely difficult time beginning her drawing. The assignment was to create a mixed media figure drawing on a large piece of paper. This student had not, to my knowledge, ever drawn on *that* large of a piece of paper before. All the other students were drawing away, and there she was standing and staring at the blank piece of paper on her easel. She was blocked and frozen with fear.

I had an idea that I thought might help her *find a way in*. With her permission, I took her paper and laid it on the floor. Then, I had every student in class walk across it. After about five minutes—and much laughter and delight by everyone, including the student whose paper was getting walked on—the surface was no longer pristine white. It was filled with scuffs

and footprints. The intimidation factor was removed. The student then put her piece of paper back on the easel, and she was able to begin to draw. She had found *a way in*.

Fear is really fear of the unknown. The more you create, the more knowledge you will acquire, the more accomplished you will become, the fewer unknowns you will have—and the less afraid you will be. Try to spend less and less time being fearful, self-critical, doubtful, indecisive, and distracted. Instead, *choose* to spend more time in the *act of creating* and being involved in the process. When you are creating, it is so much easier to recognize opportunities. Use fear as an opportunity to learn and grow, and as an opportunity to gain more confidence, experience, and mastery.

In creativity, there are opportunities everywhere.

Learn to recognize them. If something seems like an issue, it is more than likely an opportunity disguised as a problem, presenting itself as something to be afraid of. When I am working on a painting and I'm fearful of making a mistake or really screwing it up, I give myself permission to move forward by realizing that

I may actually mess it up. Acknowledging that fact, along with encouraging myself to try regardless of what might happen, makes it okay in my mind to just go for it. Being honest with myself removes the fear that is present when I think that whatever I do has to be done perfectly and look interesting with my first effort. When I accept failure as a possibility, it opens me up to being more free to paint boldly and courageously. It also helps me to know that if I do mess up, I can always correct, re-work, and give it another try.

In attempting this thing that I'm afraid of, I have an opportunity to create something really exciting or beautiful as well. And I have an opportunity to learn something new—even if that new thing is learning what doesn't work or what I'm not talented enough to do yet. Discovering things I don't know but want to learn, and then learning them, is in itself very valuable and empowering.

If you are afraid, then choosing action is always the best choice.

Once you start focusing on opportunities rather than fear, more and more opportunities will begin to present themselves to you. Then it becomes about choosing how you are going to make the most of those opportunities. It comes down to choosing to create or not. To take action or not.

Even though there will never be a guarantee that things will work out, you head in the direction of the opportunity and *create anyway*. Look at every decision involved in the *process* of painting as an opportunity, especially the decision whether to create or not. Have fun trying rather than being afraid to try. Choosing to go into the studio to paint is often more difficult than the actual process of painting. But if you make that choice, you're taking action. Take heart in the fact that the more you create, the less fearful you will be. Focus on the learning and the opportunities, rather than on the fear. Action *does indeed* quiet fear.

10

Process
Not
Product

I don't know about you, but it seems as if, every time I start a new project with a preconceived idea of how it will turn out or how I want it to look, it rarely matches my vision. If I try too hard to steer the piece in a certain direction, I am often at a disadvantage from the start. My paintings seem to have a mind of their own. More often than not, they take their own direction and go where they want to go. What works better for me is to *collaborate with my creations.*

Have you ever been working on a painting when, all of a sudden, something happens on the canvas that you weren't expecting? Did it derail you? Shut you down? Stop you in your tracks? Interrupt your momentum? Me too. And it happens often. Nevertheless, it doesn't have to be a problem. All that happened is that you were

trying to force your painting to go in a direction that it did not want to go. And it told you so.

The worst thing that you can do at this point is put your head down and, with dogged determination, continue to try to force a painting to go where you want it to go or where you think it *should* go. More than likely, you will end up getting frustrated. You might even give up on your creation. A better way to go, for both you and the painting, is to collaborate with it. Give and take.

Head in the direction that you think you want it to go, but be open to change.

Pay close attention to what is happening on the surface as you work on it. Watch what happens when one color blends into another. Be open to unexpected ideas, juxtapositions, and relationships that develop. Be open to new colors, textures, and shapes that emerge in the process. Give them the consideration that they deserve.

Will these unexpected directions make the painting better? If the answer is *yes*, then be willing to go in these new directions and try

them out. If the answer is *no*, then continue to try to make things work and continue to listen to your painting. If you decide to head in a new direction, you might be pleasantly surprised.

A work of art usually responds positively to collaboration.

So here we are. My painting and I. I begin, and the painting starts talking back to me. It suggests, it urges, and it gently nudges. I look, I observe, and I listen. I begin to make choices based on what the painting is trying to tell me. We fight. We argue. We compromise. But mostly we go with the ebb and flow of each other. And, eventually, we come out on the other side— together. Luckily, the painting rarely looks like what I had envisioned in my head. More often than not, it is much better. And if not, no harm, no foul. I will have learned something in the process, and then I try something else.

When I paint, my intention is to focus on process not product, effort not outcome. This is not always easy, but when I embrace this approach, my work usually ends up being better. Detaching from the outcome reduces fear, preciousness, and the sense of risk.

I often tell my students, *"Don't fall in love with your painting too soon, and don't hate your painting too soon."* If you fall in love with your painting too early in its development, you begin to be precious with it. You don't want to ruin it, so you end up decorating around the part that you fell in love with. And then the painting falls flat and goes nowhere. If you end up hating your painting too soon, then you may give up on it before it has had a chance to develop and become something special. Stay neutral and focus on the process. Focus on the making of the painting. Be fully present while you are creating.

Create because it is fun, challenging, satisfying, and an opportunity to learn something new.

It is not important for you to love everything you make. I aim to not have "liking my painting" be my primary goal. While I do hope I will like my painting when it's finished, it never works out for me to *need* to like it. If I had to like everything I create, I think that would force me to create from a safe place and not take any risks. This would eliminate all the fun and spontaneity from the process.

Instead, my main goal is to always *enjoy the process*. Then I try to go beyond what I did with my last painting. This requires risk, curiosity, playfulness, exploration, discovery…and yes, failure. It does not involve *liking* the painting, especially during the making of it. You can even dislike what you are currently creating. The important thing is to *be creating*. Always. Make your art. Get involved in the process. Push yourself. Have fun. Look forward to possibly loving what you create, but don't paint to *like*. The more you create, the more chances you give yourself to create things you really love.

Put your focus and energy into the making of the work. Suffuse the process with passion, curiosity, fascination, and intention.

Creating a really good piece of art is hard enough without putting pressure on yourself to do so. For me, I always create a much better painting when I focus on the *making* of it, rather than the *quality* of it. The quality of my paintings seems to be highest when I have allowed myself

to become totally engrossed in the process. By immersing myself in the creation of a piece of artwork, it allows me to have more fun with it. When I'm having fun with my work, my exuberance for creating shows up in the finished work.

Many years ago, I was creating several large portraits for an exhibit. I had never painted portraits this large before (approximately five feet tall by four feet wide), which intimidated me. I spent hours and hours drawing, focusing only on correctness. I was not having any fun at all, and the work was excruciatingly tedious. All I could think about was that, because of their large size, the portraits had to be extra accurate. Any imperfections would be magnified. At this point, I was thinking too much about the finished product.

It wasn't until after I started painting that I began to focus more on the process. The technique I was using at the time was to layer several thin washes of paint, from light to dark. As I was applying the washes, the paint aggressively dripped all over the surface of the drawn faces. I was ecstatic. I became so enamored with the drips that I began to explore how I could create the most effective and aesthetic drips possible.

Instantly, I was transported from worrying about the finished portraits to being immersed in the process of creating drips. Now I was having fun, and the drips ended up being a major component of the finished portraits. Because of the shift from focusing on product to focusing on process, the finished paintings came out much better and were far more interesting and fun to create.

In my classes, I can always tell if a student is focused on the process and having fun, just by looking at their work. I can see the joy in the colors they are using, the delight in the shapes, and the passion in the brushstrokes. Conversely, I can see a student's boredom and disinterest reflected in their work as well.

Art-making is about *doing*. It's about *creating*. It's about being involved in the process of making something. The reason to create is to experience the artistic process. Do not rush. Savor the process. Be fully engaged. Disappear into the activity for a while. Get your hands dirty. When you're fully engaged in the process, time loses meaning and nothing else matters. That's where the fun, excitement, and satisfaction of creating exists.

CHAPTER 11

Risk is Risky

To create is to risk. To be a creator is to be a risk-taker. To some, just the idea of taking risks can seem scary and dangerous. But taking risks is important and essential for artistic growth. Risks push you and challenge you to get better at your craft. They help you explore and discover. They help you innovate. And believe it or not, they can actually help you have fun creating. If you really want to move your creativity to the next level—whatever that is for you—consider taking more risks.

Risks don't always have to be big, like trying to paint the figure when you have been a landscape painter all of your creative life. They can be small, like trying a different color blue from the one you normally use. The important thing is to take *lots* of risks. *Often.* If you are new to risk-taking,

try taking smaller risks at first, which will make it easier to take bigger risks later.

Risk-taking is not easy. However, it is essential if you are really interested in creating meaningful work.

Risk-taking will feel dangerous. It can be frightening. It will most likely conjure up doubt, shake your confidence, and cause you to question your commitment level. Know all of this. Be ready for whatever comes up for you. And then, take risks anyway. Allow risk-taking to feel risky. Because it is.

Having said all of that, I am going to let you in on a little secret. Taking risks is not as scary as it seems. As a matter of fact, once you get used to taking risks, it can be fun and even thrilling. You can actually become hooked on risk-taking.

I have created some of my best, most interesting work when I somehow managed to summon the courage to let myself take big risks. For example, I submitted a proposal to be the first-ever artist-in-residence at the San Luis Obispo Museum

of Art. I proposed an idea that seemed risky but exciting at the same time. Long story short, we took one of the gallery spaces in the museum and turned it into my "studio." Over the course of two months, I would create ten large-scale, mixed media figurative pieces, all while being open to the public. This meant that visitors to the museum could come in anytime, watch me work, and interact with me.

When I first proposed this crazy idea, I knew it was risky, but I was enthusiastic about doing it. I was all in and excited to get going. And then... on the very first day of the residency, when I walked into the gallery space that we had turned into my studio, I saw the ten large, blank wood panels hanging on the wall...and my heart sank. What had I gotten myself into? I became nervous, afraid, and filled with self-doubt. That was the moment when I realized that what I was about to do was RISKY. I now understood why everyone else thought I was out of my mind, yet praised me for being so brave. After all, there was no way to predict what was going to happen or how this was going to go. Would I humiliate myself? Would the work be awful? Would people even show up to watch me work or see the pieces?

I took a few moments to collect myself, took some deep breaths, and began to work. I know myself really well, and I know that once I start working—because I love the process of creating so much—my fear and self-doubt tend to dissipate and fade away. Which is exactly what happened. I was off and running.

I created and finished the ten pieces within my two-month timeframe, met hundreds of fantastic people, and had incredible conversations with many of them. And the ten paintings came out really well (if I do say so myself). I would never have had this amazing experience had I not taken the biggest risk I have probably ever taken with regard to my creativity.

Taking risks is the only way I know of to push my work to higher levels of innovative creativity, better quality, and enhanced aesthetics. When I take risks, I always learn something in the process. If I am being precious or timid with my work, it shows up in the finished painting. Therefore, I aim to approach my paintings with an attitude of playfulness even if the work is depicting a serious or mature idea. In essence, I am still trying things and taking risks; however, being playful allows me to find a way in and have fun with it.

Let risk-taking be dangerous and scary for a while. Be ready for the reality that it will feel that way. When you embrace the realities of creating, then risk-taking will not feel so daunting.

If the idea of taking risks makes you want to run and hide, try replacing the word *risk* with the words *explore* or *curious*. For example, rather than "this seems like a big risk that I'm afraid to take," try "I'm going to explore this," or "I'm curious to see what will happen when I try this idea."

Be a risk-taker and look forward to what can happen as a result of challenging yourself.

I do realize that creating can sometimes be quite overwhelming, especially when you are in the midst of making what you hope will end up being a cohesive body of work. The pressure to create a consistent group of paintings or sculptures or photographs (or whatever it is that you create) can cause anxiety. This anxiety comes from not knowing what to do next or not being able to control the outcome, which is why it is

important to focus on the *making* of the pieces. You will at least have some control over the *process*, and this will lessen your anxiety.

It is imperative that you allow yourself to detach from the outcome in order to really engage in risk-taking. Risking is easier to do when you're focusing on the process rather than the outcome. Let the finished product become what it is going to become as a result of the risks you take. Risking failure invites meaningful growth, which means you need to push through setbacks and keep working. It will require that you try many things, take risks, and fail often.

Every time you take a risk, be it big or small, you will learn something. Even if it means learning what did *not* work. Taking a risk and learning from it will empower you to take more risks. Embrace this fact.

Think of taking risks as a tool you can use to be more creative.

I work in a series format, so I tend to create many paintings on the same theme. I love

being able to dive deep into an idea or subject and explore the many variations that are possible. In order to manage my mind as I work on a series of pieces, I realize that every piece I create on my journey toward developing a cohesive body of work is *not* going to be a winner. There are going to be some duds. I will definitely create some pieces that will not end up being part of the series.

This happens when I am taking risks, exploring, trying things, being curious, pushing my medium, and pushing myself. Just knowing that some of the pieces I create will not end up as part of the series allows me to create with more freedom. This takes the pressure off of having to play it safe in order to create pieces that hold the series together. Plus, I get to learn all along the way. Otherwise, if each piece is too precious, the work will never go where it needs or wants to go.

Creating is all about courage, being involved in the process, making stuff, experimenting, trying things, and taking risks rather than playing it safe.

The fun is in the process. The process is where the exhilaration of creating can be found. The process is where the really good, interesting, and surprising pieces come from. Leave preciousness at your studio door and create with reckless abandon.

Years ago, I started a series of mixed media drawings based on the emotions I felt after the deaths of each of my parents. I was having a very difficult time even beginning these pieces. My brain had jumped in, and, before I knew it, my mind was controlling the way that I was approaching this project. Here are some of the things I began telling myself:

I bought these expensive wood panels to work on. What if I mess them up?

These panels are too big to work on lying flat and too small to put on an easel. I don't know how to work on these things.

I can visualize how I want the finished pieces to look. What if I can't create what I envision?

These pieces are about my parents. They have to be perfect.

As you can see, I was really afraid to begin these pieces, and I was putting so much pressure on myself to get these drawings right even before I began working on them. I was overthinking it. Ultimately, I think being fearful was a good thing because it told me that I was about to try something really risky, and something that I cared deeply about. What needed to happen was for me to begin. To start. To get going. I just needed to relax and trust my intuition and my skills.

It was time for me to treat these pieces as if I were on a journey, a search to find the right line, tone, value, smudge, shape, texture, and color. And then go from there. My plan was to take risks and embrace the accidents, mistakes, and opportunities as they presented themselves. I felt that it would be best to head in the direction of what I wanted these pieces to look like, keep at it, build momentum, and have fun with the process. In other words, I just needed to *find a way in.*

The trials and tribulations I went through at the start of these pieces was one of the roughest beginnings to a series I have ever had. In the end, I was able to take my brain out of it and

create them. But it required some serious mind management. As a result of having to jump through all those mental hoops, they (with the exception of one or two) were some of the best works I had created up to that point. This is why I try to create with my heart and soul as opposed to creating with my brain. This is why I put so much emphasis and focus on being totally involved in the process.

Each painting has its own journey, its own flavor, its own quirks, and its own subtleties, which can only be unleashed by taking risks with them.

You work hard. You create painting after painting, and you finally get one that you really like. You celebrate for a moment, and then start the next painting with high expectations and the hope that you can duplicate your previous success. You try to repeat the exact same process, from start to finish. This is another trap that you can fall into if you don't continue taking risks. I have personally found that if I try to repeat a successful process with the goal of duplicating

what I just created, it never, ever works. Or,
rarely. The new painting is at a disadvantage
from the start.

As an artist, each time you create a new painting,
you have different thoughts, moods, and feelings.
You are in a different headspace with each new
painting. For me, a successful painting is usually
created with freedom. I am relaxed, having fun,
and totally involved in the process. I have no real
expectation of how it will turn out. I am creating
this painting from my heart and soul, and I am
taking lots of risks while I am creating it. It
works best if I do not heap a ton of expectations
onto my next painting in an attempt to duplicate
one of my previous successful paintings.

Instead, it works much better if I start a new
painting with the two or three steps I used to
begin my last successful painting. Then, I don't
follow a prescribed plan. I take lots of risks and
let this new painting take me where it wants to
go. I remind myself to focus on process rather
than on the end result. I aim to embrace risk-
taking as a necessary component of creativity.

CHAPTER 12

Surviving Setbacks

Whenever I start a new project, I am excited and full of hope. I begin and predict success. However, as you know, it is very hard to create on a daily or weekly basis and not experience some setbacks and failures. These just come with the territory. (Wait. Did I say failures? I meant to say opportunities!) For example, I may have a painting that is not going the way I expected, or I might make what I think is a terrible mistake. I might feel some self-doubt, want to procrastinate, or go through periods where everything I try falls flat. Or maybe I haven't been inspired and just haven't felt like getting out into the studio for a couple of weeks (or longer).

There is also life, which I may have allowed to get in the way of my creative time. Maybe I had to go out of town for a week. Or had house

guests for the weekend. Or had to attend to family matters. Any of the above can cause setbacks, and they can especially kill the momentum I was experiencing before the setback happened.

Here are two simple suggestions that might help you find a way back in and restart your creativity when you have experienced a setback, no matter what the setback is.

First, remind yourself how much fun it is to be creative and to make stuff.
Next, realize that you do not have to create something earth-shattering every time you attempt to restart your creativity.

Remind yourself that you love the process of creating. You love trying to mix the exact color you want and then trying to apply it in just the right way to achieve the desired effect. You love the feel of the pencil as you drag it across the paper in search of the perfect line. If you are a sculp-

tor, you know what you love about your process, tools, and preferred medium. If you're a photographer, you know what it feels like to be behind the lens of your camera looking for the most aesthetic image and composition you can find.

While the first step is to remind yourself how much fun creating can be, the second step is to realize that you do not have to create something original, amazing, or groundbreaking when you restart your creativity. Start from where you were before the setback. Start with something familiar. Start with what you know, and see where it leads. The goal is to get started again, begin the process of creating, and regain your momentum.

It's not necessarily about what you are creating in the moment. It's about getting involved in the process again.

Here is a type of setback I sometimes experience when I finish a series of paintings. When I start a new series, the possibilities are endless. I ask myself, "What is going to happen? Where will this take me? What am I going to learn?" Then I immerse myself in the process. I live, eat, sleep,

and breathe my ideas and my paintings. I can't
stop thinking about them. I can't wait to work
on them every day. And sometimes, when I fin-
ish, I experience a bit of a letdown. There is an
emptiness. I find myself lacking inspiration and
motivation to start another series. A feeling of
"Now what?" sets in.

When this happens, instead of forcing myself to
start another painting with no inspiration or
motivation to back me up, the first thing I do is
take a few days off. I rest, rejuvenate, and am
kind to myself. I might pull out some art books
that feature a few of my favorite artists, hoping
to find a kernel or nugget of inspiration. I might
pour through my sketchbooks and journals with
the intention of rediscovering an idea that I have
forgotten about. Lastly, for years I assembled
scrapbooks of images torn from magazines that
inspired me at the time. I might scour several
of these looking for anything that could reignite
my creative flame and get me back into the
studio.

The next thing I do is begin to jot down ideas,
thoughts, words, and lists of things as they
come to me. I also might dive back into my
sketchbook and just let the sketches happen

with no judgment as to their viability for future paintings.

What *doesn't* work for me is to go out and buy a nice, fresh, new canvas and then sit there and stare at that intimidating, pristine, white surface, waiting for inspiration to strike—as if I have to create my next great painting right now! That's too much pressure. And no good creativity \comes from that kind of pressure.

Judgment or criticism from others can also cause setbacks. The thing to know is, if you create something and put it out into the world, criticism will happen. *You* will be judged. Your *creativity* will be judged. And there is nothing that you can do about it. You cannot control how others react, think, or feel about you or your art. Judgment is part of the big picture of being a creator, just as doubt, fear, and loss of motivation are.

What works best is to create anyway and not let judgment prevent you from putting your creations out into the world.

You may be praised and criticized by others; however, your own thoughts and feelings are what truly matter. Your own thoughts and feelings dictate how successful or unsuccessful you consider yourself. Other people cannot make you feel proud or disappointed. Only you can do that.

Judgment by others can't really hurt us anyway. Judgment is just someone else's words and thoughts. What hurts us is what we make those words and thoughts mean about us, our character, and our potential—which can then cause us to doubt ourselves, which can then lead to creative blocks and setbacks.

When I was a student, I took an illustration class that was run like this: Every week, the instructor would give us an assignment that was due the following week. At the beginning of every class, we would all place our paintings on the critique rails that ran along three walls of the classroom. It was very impressive to be surrounded by all of the paintings for that week.

The instructor would come in and slowly make his way around the room, looking intently at all of the paintings. Any painting that he felt was

not good enough to talk about, he would turn around to face the wall. Then, he would proceed to critique the remaining paintings that were still facing the class.

This happened every week for the entire semester. And do you know what? I never had one single painting critiqued—because every week, my painting got turned toward the wall.

Talk about judgment! This brutal critique method took quite a while to get used to, and required lots of mind management on my part. I told myself that this was not a personal attack on me (even though it felt like it week after week). I had to constantly remind myself that my art is not me—and then work on convincing myself that this did not mean I was a terrible artist who created terrible paintings. After all, this was just one person's opinion.

You might think I didn't learn anything from that instructor, but there was one important takeaway. I learned how to manage my mind through difficult exchanges with people giving me their opinions about my paintings. And this has proven to be very valuable throughout my entire creative life.

So remember: You are not your art. And people's judgment is just their opinion. Don't make it mean anything about you as a human being, because it doesn't. Do not fear being judged. Don't worry about not being taken seriously as an artist. Make the art you need to make and put it out there.

Be proud that you have done the courageous and difficult work of being a creator. Be proud of what you have accomplished. And then get back to work.

Another way we hurt ourselves is by comparison. No matter how good we are at our craft, someone is going to be better. So what? We create because we love it. We are as good as we are right now. And yet, we are going to keep creating, learning, and getting better. And this will always be so.

When you see a painting that you respond to by another artist, the natural tendency is to compare it to your own work, especially if it is

a similar subject matter or style. We often use this comparison to degrade our own creative efforts. Instead, I suggest that you find something about this other artist's painting that really inspires you. Make a note of it, and then—when you are back in your studio—see if you can incorporate (not copy) some of what that artist did into your own work. Furthermore, you could use another artist's work or achievements as an inspiring example of what is possible for you and your creativity.

Use comparison as inspiration, not punishment.

Here is an example of how I avoided another potential setback. I was working on a particular series of paintings that were especially challenging for me. At some point, I began to notice that my images were just sitting there. Doing nothing. Saying nothing. Even though I was totally into the process and enjoying the work, I felt as though I was moving further and further away from what I wanted, rather than toward my desired outcome. The work felt stiff and was definitely missing something.

A realization like this is primed to cause a set-

back, shutdown, or creative block, but I decided to carry on and see what I could do to resurrect these pieces. In my desire to breathe life back into them, I realized that I had the opportunity (and obligation) to breathe some life back into myself as well. I discovered that it was my attitude and approach that was "missing something." It was not the fault of the collage and paint. What was missing in these pieces was my emotion and passion, which was obviously not showing up in the work.

Lifeless Approach = Lifeless Art. The emotion and passion had to come from me, and I needed to inject that into my work.

As I continued to create and head in the direction that I wanted my work to go, I learned more and more about art-making—and, more importantly, I learned more about myself. Amazing how that works, yes?

If you're having setbacks, all it means is that you are learning and growing as an artist. Keep

working. Don't let setbacks shut down your momentum. Start with a fresh mindset in your studio every day. Predict success. Risk failure. Expect setbacks. Know that they are bound to happen at some point in your creative process. And *create anyway.*

CHAPTER

13

Brushes Down

Brushes down is what I tell my students when something has interrupted the flow of their creativity. This could include:

Getting stuck and not knowing what to do next

Becoming frustrated

Doubting yourself

Thinking you have ruined your painting

Hating what you have done and wanting to quit

When an artist experiences any of the above, they often have a tendency to panic. That's when I tell them *brushes down*—which means: *Stop.* Take a deep breath and step away from the painting for a few minutes. Then, come back and really look at it.

Brushes down literally means to put the brush down, but it also means to be kind to yourself at this crucial moment. Being kind to yourself means not getting frustrated or angry with yourself for making a mistake, and certainly not beating yourself up for not being able to do something you think you should be able to do. Being kind means being gentle with yourself and treating yourself with respect during the challenging process of creating a painting.

Let's face facts: You are most certainly going to create some bad art from time to time. I certainly do. I am not talking about setting out to create terrible things on purpose; I am talking about ending up with bad paintings because you were trying new things, pushing your materials further, taking risks (both big and small), and not settling for something nice, pretty, or safe. As a result of these aggressive and commendable efforts, you may end up with something less than desirable.

Remember, things cannot be both new and perfect at the same time.

Let's not forget that, in spite of the fact that you created this less-than-satisfying piece of art, you also learned a lot, and you experienced tremendous growth as a creator. You learned what works and what doesn't work for you, which you can then use in your next creation. To create is to risk. The more paintings you make, the better artist you become. Also, the more bad paintings you create, the better artist you will be in the long run.

Being courageous enough to risk failure is so much better than being fearful or having self-doubt.

We have to go for it. We're not attempting to create something that is good, safe, easy, or likable. We are trying to create work that is passionate, emotional, powerful, stunning, amazing, beautiful, intriguing, funny, dangerous, shocking, odd, whimsical, thoughtful, or provocative. We want to stop people in their tracks and make them pay attention to what we have created. Push, risk, try, make bad stuff. As a result, we will learn to make better and better art.

When we make a "bad" piece of art, our tendency is to want to "fix" it, to paint out all of the mistakes or discard the painting and start over, before we have even given ourselves a chance to make it work. If you are using the word *fix* to mean, "Something is wrong with my painting, so I need to *fix* it," I suggest that you eliminate that word from your vocabulary. To me, the word *fix* implies that a painting is broken and needs repairing. First of all, there's really nothing wrong with your painting. If you're thinking that you need to fix your painting, what it really means is that your painting is not *there* yet. It means that your painting is currently not looking how you want it to look *yet*. And all this really means is your painting is not finished, and you have more work to do. Or it may mean that there are parts of your painting that you would like to revisit or rework. But it definitely does not mean those areas are broken.

Don't give up on your painting. Give your painting the opportunity to come into fruition, to be born, to exist. I understand there are times when a painting becomes hopeless and we must let it go, but these times are rare. I have learned way more from paintings that were difficult and that I struggled with than from paintings that, for some reason, were easier to create. I certainly

don't learn much from paintings that I give up on prematurely.

Eliminating the word *fix* from your vocabulary will provide you with a much healthier way of self-evaluating your work in progress, and will help you have a better attitude about going back into your painting if you decide to rework it.

During one of my workshops, a student was clearly having trouble with her painting. When I approached her, the first thing she blurted out to me was, "I hate this!" I asked her what she meant by "this," and she said, "I hate my painting!" I asked her if she hated the entire painting, and she said, "Yes! The whole thing!!!" I suggested that she put her brush down, and then we proceeded to step back from the painting to take a look. This gave her an opportunity to just stop and take a breath.

Then, I asked her some questions and we talked about it. After some discussion, we discovered that she was actually only dissatisfied with one tiny little area down in the lower left-hand corner. To say that this type of interaction has happened many times, with many of my students, is an understatement. In most cases, when a student says they hate their painting, they usually do not really mean that they hate the *whole* painting.

All this to say that *brushes down* not only means to literally put your brush down, it also means to not overreact and panic. Once you panic, you will most certainly begin to make poor choices in a frantic effort to quickly "fix" or correct the perceived problem. You may try to save the painting as fast as you can in order to feel better about yourself as an artist. But the painting doesn't need saving. It doesn't need to be fixed. It is not broken. If you have made a misstep or don't like an area of the painting or it doesn't meet your expectations, it just means that *you are not finished yet.* That's all.

Put your brush down and walk away for a few minutes.

Then, come back to your creation in progress and look at it. Really look at it.

Don't pick up the brush yet. *Just look.* After a
few minutes away, it often turns out that the big
mistake you thought you made is not such a big
mistake at all. Perhaps you can now see that it
was simply a miscalculation. Often, after put-
ting your brush down and walking away for a
few minutes, you will see the problem and the
solution much more clearly. It's hard to think
straight when you are disappointed, frustrated,
or in a panic. Remember to be kind to yourself.
You do not want to beat yourself up. Ever. And
especially not because you think you have made
a horrible mistake.

If, upon returning to your painting after a short
break, you do not see a solution right away, work
on another area of the painting. Or better yet,
work on a completely different painting for a
while. More often than not, I come up with a
solution for the painting that I am stuck on
while I am working on a different area of that
painting or while I am working on a completely
different painting altogether.

If this doesn't work or you just can't keep your eyes off of the part of the painting that you are not happy with, paint out just that section and try again. Or erase it, rub it out, collage over it, or do whatever you need to do with your particular medium to get a fresh start. When you paint out an area, it's gone and you get to start over. You create a new opportunity for yourself and, more than likely, you will have learned how to proceed.

You are going to make mistakes, missteps, and miscalculations, especially if you are pushing yourself, trying new things, and taking risks. Mistakes go with the territory. It could be mixing a bad color, designing a boring composition, drawing something out of proportion, or overworking a painting. Personally, I learn way more from mistakes than you might think. But really…there are no mistakes. There are only opportunities, choices, and unfinished pieces. A mistake just means that you have more work to do. A mistake is only a mistake if you choose to leave it in your picture and do nothing about it. A mistake just means that you aren't *there* yet, that you haven't found the right solution *yet*, and that it doesn't look the way you want it to. Mistakes are just part of the aesthetic layering

within the painting. A mistake is an opportunity to choose, to learn, and to grow.

If you've made a mistake, don't panic. Stop. Don't be in a hurry to cover it up. Nothing is wrong. Brushes down. Step back. Take a look. The mistake is not going to get any worse while you are deciding what to do. When you step back to take a look, don't just focus on the mistake. Look at the entire picture. What did the perceived mistake do *to* or *for* the piece as a whole? Did the miscalculation make the picture worse, better or...possibly more interesting?

Consider that mistakes, accidents, and miscalculations may actually be an asset rather than a liability. Drawing or painting miscalculations are not a disaster. And, please don't use them as evidence to believe that you are *not* a good artist.

Believe it or not, you can survive even if you make a mistake.

Surviving mistakes is all about staying with it and continuing to paint—and not letting these missteps shut you down. Surviving mistakes is

about not letting them get the best of you. Embrace the miscalculation. Is it really a mistake, or is it just something that happened that you didn't expect? Might this unexpected thing that happened be good for the painting? Might these mistakes actually be even better than what you intended?

Brushes down can help you make decisions during the process of creating. And it can help you manifest some much-needed patience with yourself and your painting. This allows you to have more fun during the process.

Brushes down can make the creative process more enjoyable and rewarding.

When I am painting, I am all in. I am painting hard. Then, at some point, I stop, put down the brush, and I look. And I look some more. I really try to see what just happened. What changed? What got better? What got worse? How did the last brushstroke affect the whole painting? What do I like? What do I dislike? I evaluate. I take my time. What is working? What is not working? What is next? I contemplate my next move. I weigh my options.

I also assess *myself*. Am I calm and at peace with the process and myself? Am I seeing clearly? Am I capable of making good decisions right now? If I can say yes to all of these questions, then I can continue painting. If the answer is no to some or all of these questions, then perhaps it is time for a longer break, time to work on a different painting, or even time to stop for the day. If everything is working, based on my evaluation of the painting, and I know what I want to do next, then I'll dive back in for another one of my intense working sessions, which for me are usually half-hour bursts with short evaluation breaks in between.

But this is me. This is *my* preferred working method. It may not appeal to you. It is different for every artist. If you haven't already done so, you will find your own way of working. For me, savoring the process is a much better, more peaceful, and more enjoyable way to create. And it allows me to create better work.

Employing my *brushes down* technique allows me to be more flexible with my painting process, which works best when I am willing to respond and adapt to the changes that happen on the surface of my canvas as I work on it. Do your

best to adjust to the changing conditions and new circumstances as they present themselves. *Brushes down* gives you the time and space you need to make the best decisions for your painting.

Mastering flexibility is essential to being more creative and making better paintings.

Even more challenging is having the flexibility to adapt to your own ever-changing thoughts about the painting in progress. You start with an idea. You visualize how you want it to look. You begin to actually create it. Everything seems to be going well. You're having fun. Then something happens, something you didn't expect, and you don't like the result one bit. You try something else. The work veers even further away from your original vision. You try to bring the work back on course. It wants to go in a different direction. But you don't want it to go in that new direction.

At this point, you may get frustrated. Thoughts of giving up enter your mind, along with self-doubt, fear, anxiety, and panic. You may even

want to start over or quit painting altogether. This doesn't mean that you are a terrible artist. It just means that you *are* an artist. It just means that the painting is not complete yet. It just means that you have more work to do.

You can fight this new direction that your painting wants to take you in, or you can be flexible and open to going on a new journey with it. If this were me, my brushes would have been down many times during the scenario that I've just described. *Brushes down* keeps me from spinning out of control or from getting derailed when things are not going so well. Chances are, there will be something amazing to learn regardless of what happens.

Paintings have a life of their own. They tell us how they would like to be developed.

So be flexible. Be willing to allow your painting to take you places you may not want to go at first. Be willing to let your creation become something that you did not expect. Be willing to collaborate with your painting for a more enjoyable artistic experience.

Patience and flexibility require hard work, but with practice they can be powerful allies in your quest to be creative. And they are well worth the effort to master. It all starts with *brushes down*.

For a guide that helps you assess and critique your own work, go to:

www.CreateAnyway.today/critique

CHAPTER 14

The Confidence to Finish

I have spoken a lot about beginning a painting, as well as about the pitfalls and obstacles artists face during the process of creating. However, it is just as difficult to *finish* a painting as it is to *start* a painting. Finishing a piece requires that you make a commitment. Finishing requires that you make the ultimate decision. Finishing requires that you have the confidence to proclaim to both yourself and others that the piece is complete.

When you decide that a piece is finished, you're telling yourself that you are satisfied (at least for now) with what you have just created and completed. You demonstrate to yourself that you value your accomplishment. You have made something that pleases you, and there is nothing more you can (or choose to) do to make it any better. This is what confidence looks like.

The good news is that each time you decide that a piece is finished, you build self-confidence.

Declaring that a piece is finished also requires that you have the confidence and courage to handle the potential and eventual criticism that may come your way. Upon completion, not only will you be judging your work. Others will, too.

Judgment comes with the territory of completion. Critical assessment is part of the natural evolution of creativity. Know that judgment will be there as soon as you finish a painting. The first judgment will come from *you* as you begin to evaluate what you have just created. Judgment will also present itself as soon as you show your painting to anyone else. Finish your paintings and put them out into the world. Criticism is not to be feared. Instead, welcome it as an opportunity to learn and get feedback, which will help you create better work in the future as well as develop a stronger mindset.

There will also be a time when you proclaim

that a painting is finished, and then look at it a week later and realize that there are things about it that you don't like. You decide to go back into it and re-work these areas. No harm, no foul. If this happens—and it will—it does not mean that you were wrong for declaring that the painting was finished and then deciding that it wasn't. It also doesn't mean that you created an awful painting in the first place. All it means is that you thought it was finished, then realized that you could make it better. You will end up being a better artist for this experience (because you will have learned things), and this painting (and future paintings) will be stronger because of your efforts and newly acquired knowledge.

Sometimes trying to create what you envision can be very difficult, and you may become discouraged. You might decide to stop working on the painting altogether, which then results in an unfinished painting and possibly a loss of confidence in continuing to paint at all. If you love creating (and I know you do; otherwise, you wouldn't be reading this book), then refuse to give up. Keep going. Push yourself. Look for clues, try things, take risks. Some of the things that you try will work and some of them won't. Carry on. Complete your paintings.

Maybe the issue is that you're being too control-ling or you have overplanned your painting. When unexpected things happen in your paint-ing (and they will), don't let that shut you down and don't abandon your painting. Take a break and then get back to it. Embrace the unexpected thing that happened and continue painting.

Sometimes it is best to allow the painting to not go according to plan.

Sometimes we have a preconceived idea of what we want our painting to look like. Sometimes we don't know at all. For me, what works best is to strike a balance between the two. I start a new painting with a rough idea of what I think I want it to look like, so I at least have a path to begin to explore. This approach makes it much harder to fail because I don't really know what is *supposed* to happen. Then at some point, I step back and assess the piece. If I don't like what is going on, it just means that the painting isn't complete and I have more work to do.

The more you create, the clearer you will become

about what you want your paintings to look like.

Painting more often will make it easier for you to know when your paintings are finished. You will also become more confident in your ability to judge your own work.

Have high expectations for your paintings. This may mean that you will have to work harder to get your creations to look like what you want them to look like. It might mean that it will take you longer to finish a painting. So be it. You want finished paintings that hopefully please you and that you are proud of, regardless of how hard you have to work on them or how long they take to finish.

I feel the need to revisit the conversation about judgment and criticism because these can also lead to artists not finishing their paintings. Please do not worry about what others will think of you or your work. I believe that we, as artists, rely too much on what others think and say about our work. We feel the need to seek approval from others. All artists have these feelings, especially those who are new to making

art. Unfortunately, when we seek approval from others, we often end up with disapproval.

When we ask someone for their opinion about our work, we usually expect and hope for approval and praise. But more often than not, what we really get is criticism. You hope the criticism will be constructive and that it will help you finish your painting. However, be ready to receive negative or, at the very least, unhelpful criticism as well. And if you do, don't let it prevent you from continuing to work on your painting. If you aren't open to any negativity, then I would suggest that you think twice about asking people what they think of your work. If you are open to *any* comments, good or bad, then go for it. Ask away.

Artists who are afraid of criticism will often keep paintings unfinished. They tell themselves that as long as the painting is incomplete, it cannot and should not be judged. I have coached many artists on this exact topic. Please do not fall into this trap. For one thing, you don't want to end up with a storage rack full of unfinished paintings. You don't want to cheat yourself out of the confidence-building that comes with completing projects.

Remember that you *are not* your work. You are not your painting.

Accept that judgments are going to happen and *create anyway*. And, finish. And then start another painting.

As an experiment, you could also try this: stop asking for feedback for a while. See how it feels. Don't ask people what they think about your art. This includes family, friends, and other artists. If someone happens to see it and offers their opinion, gracefully listen to what they have to say, thank them for their input, and then keep painting. This will help you create your art for you only, rather than for someone else. You might find that you become more free to try things you have always wanted to try. You might take more risks. And you might be more satisfied with your work. With this approach, you reduce the temptation to worry about what others think of your creations.

That said, I do think that teachers are a different story. The teacher/student dynamic is different. Teachers teach. That's what they do. They also

provide critical assessment and evaluation. Students learn. That's what they do. In this teacher/student relationship, criticism and evaluation are necessary for growth.

If you are serious about receiving criticism, then please be discerning about who you ask. You probably don't just want praise and kind, happy comments. You most likely want some educated, constructive criticism. So, ask someone whose opinion you respect and trust—and who has good intentions for both you and your work. Do not let what others say about your creations throw you off course, prevent you from finishing a painting or—worse yet—shut you down completely.

Stay focused.
Stay on your path.

Do not let what other people say about your work, your style, your technique, your idea, your subject matter, or your talent cause you to deviate from your path. People who give you their opinion about your work, whether asked to or not, think they're helping. They mean well and are usually coming from a good place, but their comments may not be helpful. Remember that

they are not out to intentionally hurt you, so it doesn't serve you to get angry at them.

Whatever they have to say about your work is not actually the thing that will hurt you anyway. It's what *you think* about what *they say* about your work that hurts. It's what *you make it mean* about you that hurts you.

Here are the beliefs that help me navigate negative comments:

This is not a personal attack.

My art is more important than any criticism of it.

I'm going to make what I intend to make.

I cannot please everyone.

Some will like what I create. Some won't.

They'll find art out there that they like.

I am not my artwork.

I am not what I create.

Criticism is an opportunity for me to learn.

People are going to give you their opinions of your work whether you want them to or not. It can get too messy when others are allowed to intervene. Hear what they have to say, accept

or reject their feedback, and continue painting. And, finish.

Stay balanced, stay focused, and stay level-headed. Get back to work. You know when your work is good and when it is not. You know when it is finished and when it needs more work. You know. Deep down. You know.

Learn to be your own best critic. This means being able to step back from your work and gently but firmly assess it—not from the point of view of the artist who created the painting, but as the critical observer. Begin to freely move back and forth from creating to evaluating. Be an honest critic and a bold creator. You know when you have given it your all and done the best you could on any given painting. Only you have the ability to recognize and confirm that a creation of yours is complete or whether it needs more work.

It is essential to practice being honest but gentle with yourself, truthful but kind, and firm but caring.

So…when is a painting finished? This is the age-old question that haunts every artist. My short, flip (and accurate) answer to this question is: when the artist says it's finished. But this answer does not really help you to make an informed and educated decision about whether your painting is complete or not.

So, for the sake of discussion, let's say that I have a vision for a painting. It helps me to establish three to five goals that I want to accomplish with this new painting. An example would be:

1 I want the surface to be filled with interesting shapes, both geometric and organic.

2 I want a broad value range, from light to dark, with several middle tones in between.

3 The predominant color is blue, so I want to explore a wide variety of blues.

A short, simple list like this gives me a place to start and keeps me on track—or gets me back on track if I get derailed. When I'm able to check off all of my goals, I know that my piece is finished.

Thus, if I am trying to determine whether my painting is finished, the first thing I would do is review my list of goals. If I can check off each of the items on my list, then, more than likely, my painting is complete. However, if there is something on my goal list that I cannot check off, then all it means is that the painting is incomplete, and I have more work to do. I am always on the lookout for whether my painting exceeds (rather than just meets) my standards. A painting that accomplishes this is usually complete as well.

I do best when I trust my instincts. I step back from my work a lot while I am creating it. I mean, *a lot*. Probably more than your average artist. And I look. Really look. I probably spend more time looking at and contemplating my work from a distance than I do creating it. This allows me to really see it and make an informed decision as to whether it is finished or not.

My initial vision and my short list of goals for each painting help me to decide when a piece is complete. To put it simply, when I have done everything on my list and accomplished all of the goals that I established for the painting, the piece is finished.

I encourage you to engage in the creative process: the making, the doing, the activity, and the time spent creating. Build something that did not exist until you built it, with the focus being on the *building*. Focusing on the process almost always leads to better, more satisfying creations. Of course, we would all love to finish something that we are completely satisfied with. However, in my experience, finishing should not be the primary goal for any creator. The act of creating should be.

Download my list of 21 criteria to help you decide when a piece is finished:

www.CreateAnyway.today/finish

CHAPTER 15

Final Thoughts

We are all creative. We all have the drive to
make our visions and imaginings concrete and
alive. The artist brings something into being
from nothing. It starts with the spark of an idea,
which then requires the ability to put diverse
things together to come up with something new.
The artist brings forth something which only
existed in their mind, and now exists in real life.
What begins with ideas and inspiration ends
in something *new*.

The reason to create artistically is to experience
the process which, as far as I am concerned, is
the most satisfying part of making art. The
choices and decisions. The thrill of an unex-
pected turn in direction or motivation. Watching
an image develop. The satisfying accident. The
artist's energy and love for the process cannot
help but reveal itself in the finished work.

The process of creating is confirmation that the artist is fully alive.

Creating is messy. I don't mean spilled paint and charcoal everywhere. I mean messy as in highs and lows, ups and downs, inspiration and blockages, aha moments and, yes, boredom. This is the life of a creator. These different phases exist and are a reality that we artists must face on a daily basis. This creative journey that you are on is going to be imperfect. It's going to be messy.

Learn how to keep creating in the midst of all these ups and downs. Do not let the lows, the blockages, and the boredom slow you down or, worse yet, shut you down altogether. Choose instead to be inspired even when things are not going well. You have the power of choice.

The quality of the work you produce, as well as the thoughts, experiences, and feelings that will come up during the process of creating, are going to fluctuate dramatically. Ride the waves. Embrace imperfection. Focus on the opportunities and look for the open doors. Empower yourself to *create anyway* in spite of whatever else is going on.

In Gratitude

I am so appreciative of all the opportunities that I have been given, especially the ones that I have had the courage to take advantage of.

I am not sure that my parents, Lloyd and Anita, were thrilled when I announced to them that I wanted to be an artist. However, not only did they not try to talk me out of it, they gave me their blessing and support. And, boy, were they proud. They also let me color outside the lines when I was a kid. Thanks, Mom and Dad.

My little sis, Sue, has always been one of my biggest fans. She has been rock solid in her support and love. I thank her dearly.

What can I say about Jordan, my love, my life partner, and my best friend. Everything I have accomplished since she entered my life would not have been nearly as successful without her. This book wouldn't have ever seen the light of day without her support, hard work, and insistence that I write it and get it done. She helped make it a reality on so many levels. She is brilliant, a phenomenal life coach, and an amazing collaborator.

Thanks also go to my very good friend, Lisa Occhipinti, a fantastic artist, author, and teacher, for designing this beautiful book.

Lori Snyder, thank you for your stellar editing.

Thank you to all of the teachers I have ever had, good and bad. I learned so much from all of them. I, in turn, have enjoyed teaching and working with every one of the students who has set foot in one of my classrooms or been a private coaching client. If they only knew how much they have taught me.

As well, I send thanks to everyone who has supported my art by either purchasing my paintings, exhibiting them, or encouraging me to create.

Lastly, thank you to those who have not liked my work. You provided me with the opportunity to practice the courage of my convictions.

About the Author

David Limrite is an experienced educator, coach and mentor. He has been a working artist for 37 years. A beloved teacher, Limrite has devoted well over 10,000 hours to fostering, motivating and inspiring students of all levels. His skill as a professional artist is undeniable, and his generosity in sharing his insights is unparalleled. He understands the challenges that artists face and can help them meet these challenges head on with his aesthetically critical eye and laser-focused guidance. Limrite has a Bachelor of Arts Degree from San Diego State University and a Bachelor of Fine Arts Degree in Illustration from Art Center College of Design in Pasadena, California. After 32 years working in Los Angeles, Limrite now makes his home in central California. You can find him and his work at DavidLimrite.com.

CPSIA information can be obtained
at www.ICGtesting.com
Printed in the USA
BVHW090522070222
628273BV00015B/450

9 781735 964102